001

002

003

005

004

006

007

008

009

010

011

012

013

PLATE 1

014

Wishing you a Merry Christmas

015

016

017

018

019

020

021

022

023

024

Plate 2

025

026

Wishing you a merry Christmas

027

028

029

030

031

032

033

034

A MERRY CHRISTMAS

Compliments of the Season

035

036

037

038

039

040

041

A HAPPY NEW YEAR

042

A Happy Christmas

043

044

PLATE 3

045

046

047

048

049

050

051

052

053

054

055

056

057

058

059

PLATE 4

060

061

062

063

064

065

066

067

068

069

070

071

072

073

074

075

076

PLATE 5

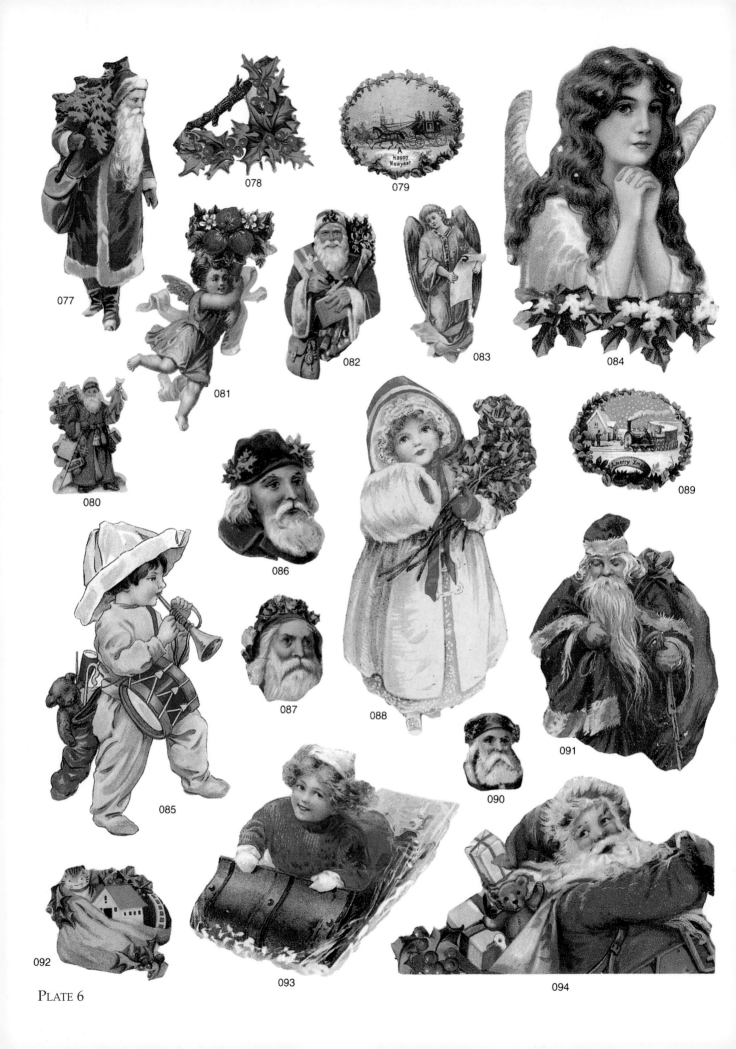

077

078

079

080

081

082

083

084

085

086

087

088

089

090

091

092

093

094

PLATE 6

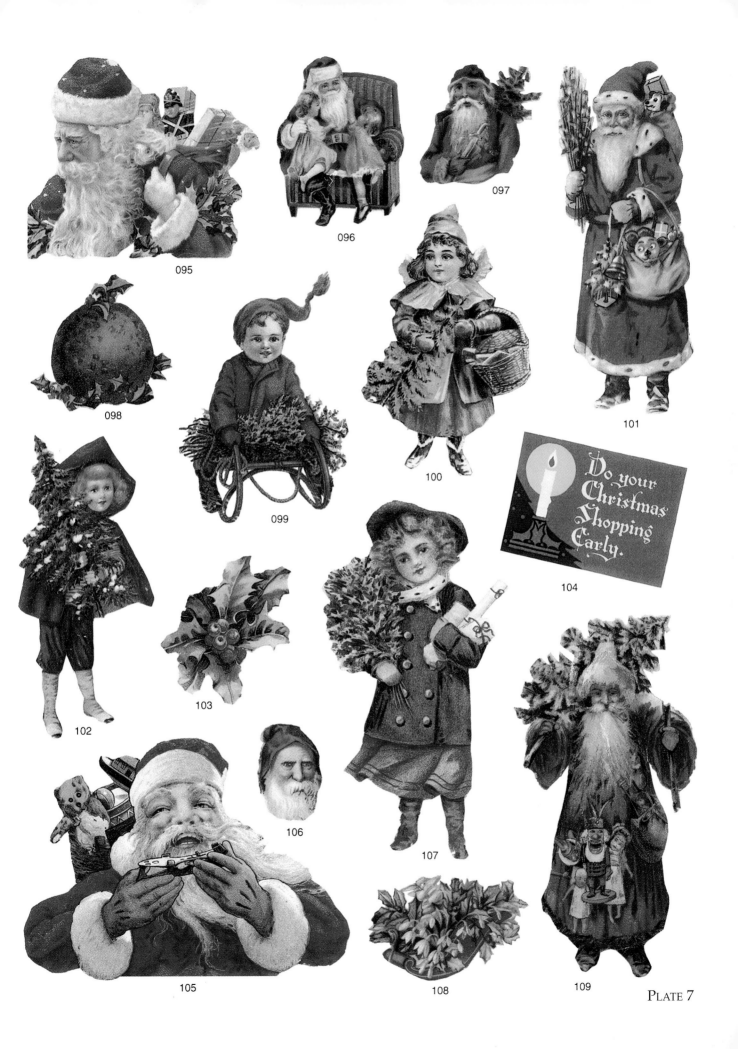

095

096

097

098

099

100

101

Do your Christmas Shopping Early.

104

102

103

105

106

107

108

109

PLATE 7

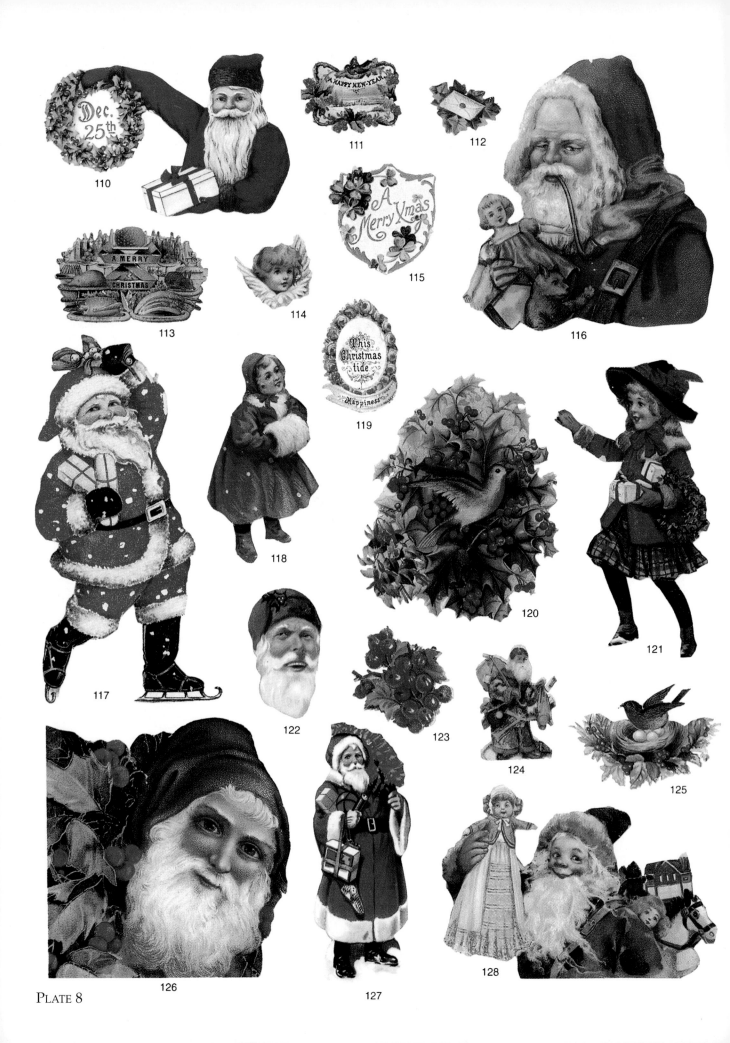

110

111

112

113

114

115

116

117

118

119

120

121

122

123

124

125

126

127

128

PLATE 8

129

130

131

132

133

134

135

136

137

December 25 Christmas Day

138

139

140

141

142

143

PLATE 9

144

145

146

147

148

149

150

151

152

153

154

155

156

157

158

159

160

PLATE 10

May your Christmas be merry and lack nothing

161

162

164

165

163

166

167

168

169

170

PLATE 11

171

172

173

174

175

176

177

178

179

180

181

182

183

184

185

186

187

188

189

PLATE 12

190

191

192

193

194

195

196

197

198

199

200

201

PLATE 13

202

203

204

205

206

207

208

209

DECEMBER
25
Christmas Day

210

211

212

213

214

PLATE 14

216

217

215

218

219

220

221

222

223

224

225

226

227

228

229

230

PLATE 15

231

232

233

234

235

236

237

238

239

240

241

242

243

PLATE 16

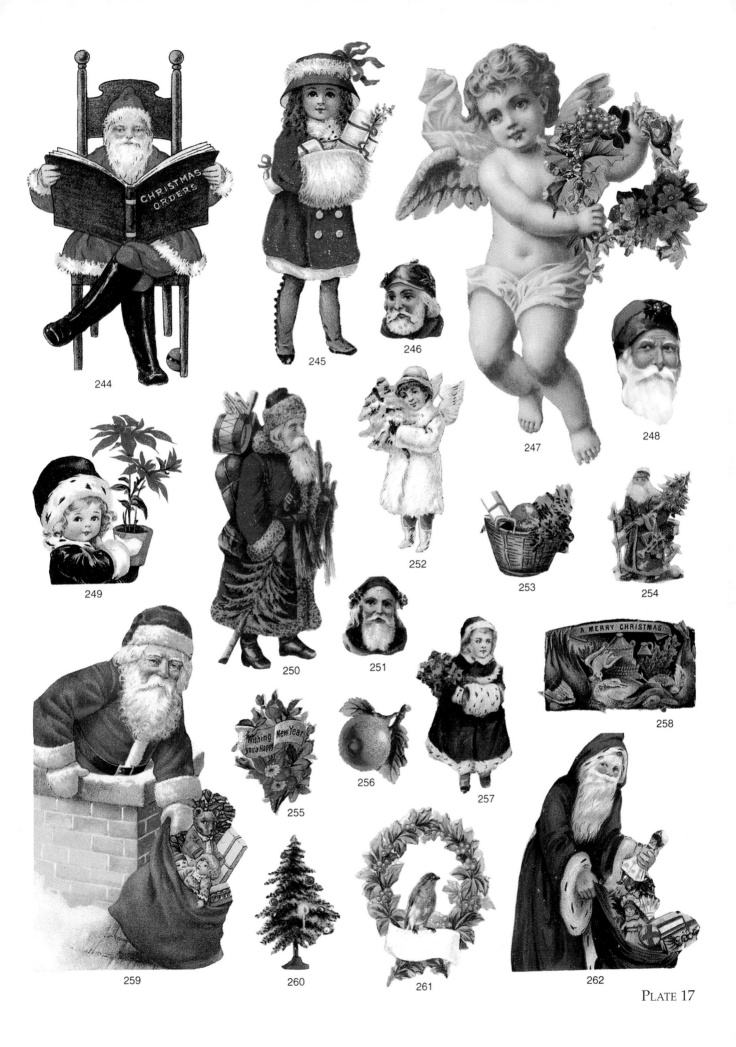

244

245

246

247

248

249

250

251

252

253

254

255

256

257

258

259

260

261

262

PLATE 17

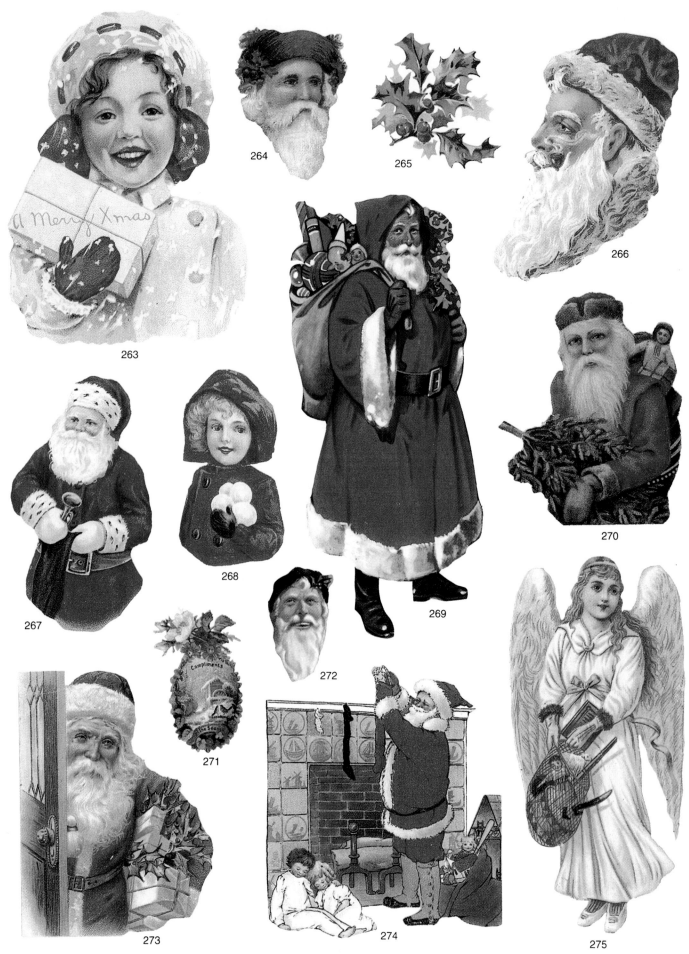

263

264

265

266

267

268

269

270

271

272

273

274

275

PLATE 18

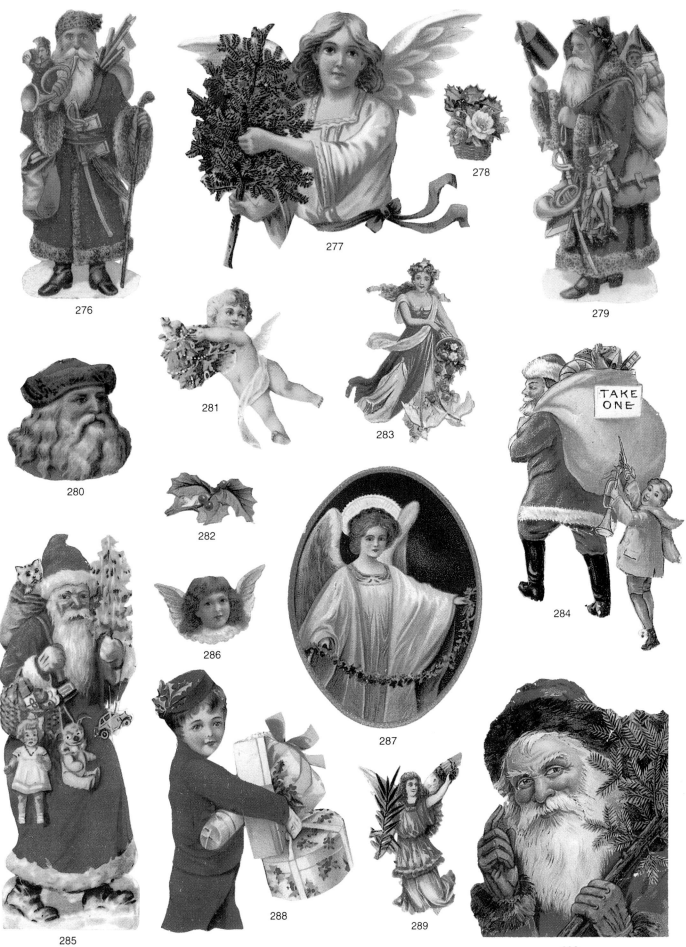

276

277

278

279

280

281

283

282

284

286

287

285

288

289

290

PLATE 19

Do your Christmas Shopping Early

296

291

292

294

293

295

299

297

298

300

301

302

303

PLATE 20

304

307

306

310

312

308

309

311

305

313

314

315

316

317

318

319

PLATE 21

320

321

322

323

324

325

326

327

328

329

330

331

332

333

334

335

336

PLATE 22

337

338

339

340

341

342

343

344

345

A Bright
and Happy
Christmas

346

347

348

349

350

351

352

PLATE 23

353

354

355

356

357

358

359

December
25
A Merry Christmas

360

361

SANTA CLAUS
EXPRESS

362

DEC. 25TH

PLATE 24

The *H. L. Hunley* Submarine

Young Palmetto Books

Kim Shealy Jeffcoat, *Series Editor*

THE
H. L. HUNLEY
SUBMARINE

HISTORY AND MYSTERY FROM THE CIVIL WAR

FRAN HAWK

Illustrated by
MONICA WYRICK

THE UNIVERSITY OF SOUTH CAROLINA PRESS

Published by the University of South Carolina Press
Columbia, South Carolina 29208

www.sc.edu/uscpress

Manufactured in China

24 23 22 21 20 19 18 17
10 9 8 7 6 5 4 3 2 1

Library of Congress Cataloging-in-Publication Data
can be found at http://catalog.loc.gov/

ISBN: 978-1-61117-788-6 (hardcover)
ISBN: 978-1-61117-789-3 (ebook)

For Anne (Angie) Sinkler Whaley LeClercq,
with my love and appreciation.
For Avery, Claire, Daisy, Drew, James, Lane, Peter,
Will, Zadie, and all the other precious children on
our planet. May the devastating lessons from
wars motivate you to promote peace.

CONTENTS

· ·

Preface xi

Acknowledgments xiii

1. The Battle of Shiloh 1

2. Lt. George Dixon and the *H. L. Hunley* 3

3. The Blockade of Charleston 7

4. Last Chance 9

5. The *Hunley* Sinks the *Housatonic* 13

6. The End of the Civil War 15

7. The Long Search for the *Hunley* 17

8. Raising and Restoration of the *Hunley* 19

9. Lt. Dixon's Gold Coin 22

10. The Future of the *H. L. Hunley* 24

Behind the Scenes at the Warren Lasch Conservation Center 27

Suggestions for Further Exploration 31

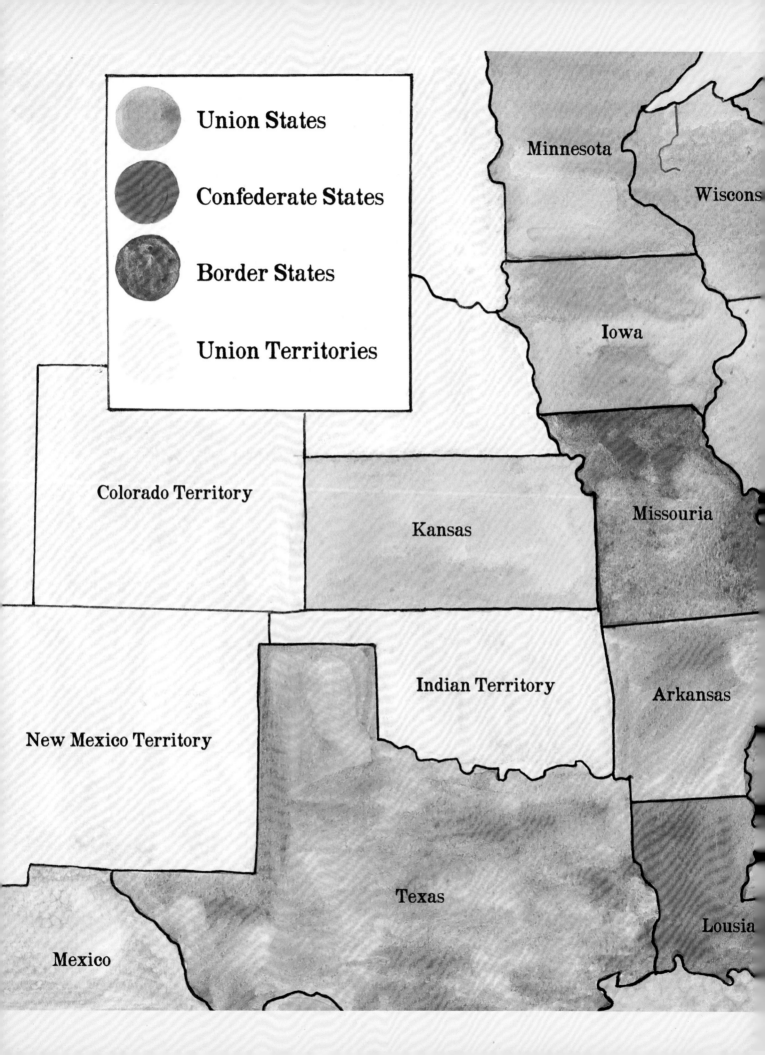

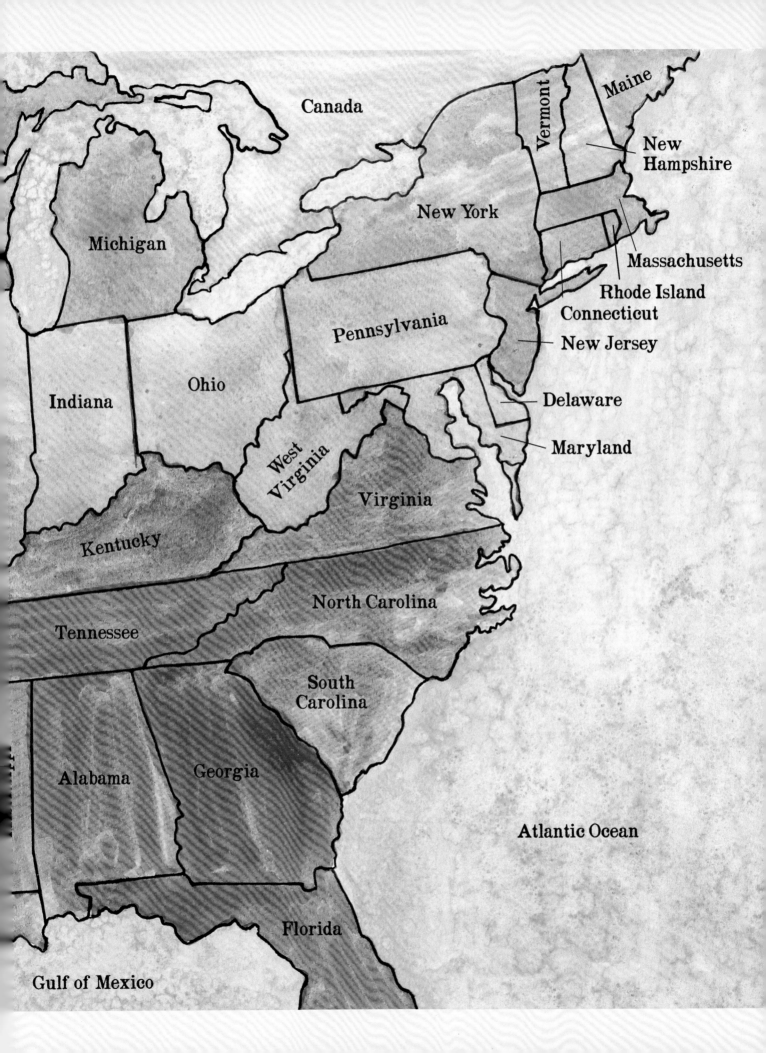

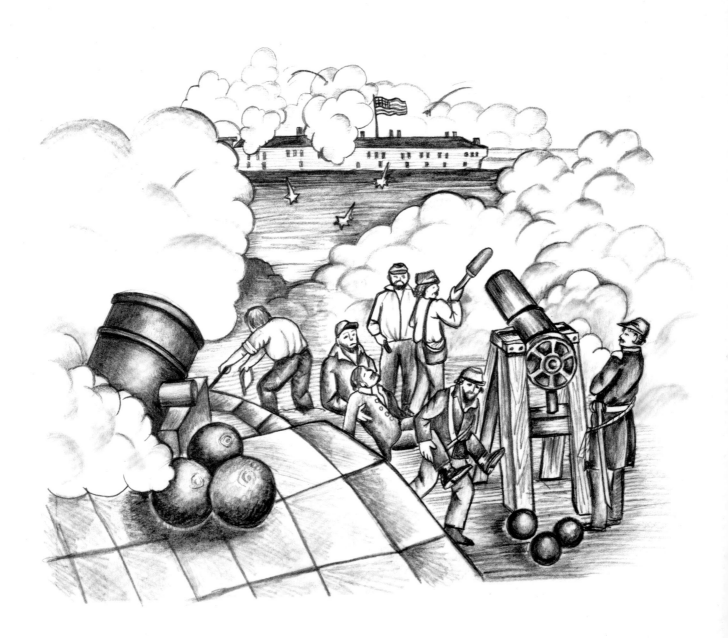

PREFACE

. .

The story of the *H. L. Hunley* Confederate submarine is foremost an American story. Horace Lawson Hunley was a wealthy entrepreneur who had the idea for this entirely private venture. He wanted to turn the tide of the Civil War in favor of his native South. In the beginning, he paid for the construction of the submarine himself. The vessel was well-designed and well-crafted in the American spirit of invention.

Toward the end of the war, the South was suffering great losses. They needed a powerful secret weapon. Hunley used his imagination, and the engineering skill of James R. McClintock, to create this amazing submarine. He believed this weapon would help the Confederates win the war.

The Southern states wanted to break away—or secede—from the United States. Their goal was to create their own country, elect their own president, and maintain their economy, which depended on slave labor. Only a small minority of Southerners owned slaves. Because the slave owners were wealthy and important, they convinced the majority of Southerners that the North had no right to take away their slaves, or to force the South to stay in the Union.

The Northern states wanted all the states to remain joined together in the Union as it already existed. They wanted one president for all the states. Many Northerners also wanted to abolish slavery.

The Southern Rebels of the Confederacy were absolutely convinced that their cause was right and just. The Northern Yankees of the Union were absolutely convinced that their cause was right and just. Sometimes brothers in the same family fought on different sides of the war.

The Civil War, also called the War Between the States, started in 1861, when the Confederates fired the first shot. The fighting spread across the

country and lasted four long and bloody years. Approximately 620,000 people died because of the war.

Both sides had dedicated men and women who were smart, full of energy and ideas, and ready to try anything that would help their side win. Then Hunley came up with his wild idea to build a "fish boat." It would be designed to operate underwater so that it could sneak up on enemy ships and blow them to bits. Could such an unusual plan actually work?

The *Hunley* is the story of this "fish boat." It is also a story of ingenuity, courage, perseverance, and love that transcended the interests of both sides. In addition, the *Hunley* story is full of mysteries. Some of the mysteries have been solved. Some of these mysteries are waiting for just the right person to find the clues, and put them together.

The Mysteries:

1. Where was the *Hunley*? (That mystery has been solved.)
2. How and why did the submarine sink?
3. Where and how did Lt. Dixon get his gold coin?
4. Who was George E. Dixon?
5. What additional clues and information exist and are waiting to be discovered?

ACKNOWLEDGMENTS

...............................

Thank you to Brian Hicks: *Hunley* guru, fact checker extraordinaire, and captain of my personal cheerleading team.

Thank you to Kellen Correia, president and executive director of Friends of the *Hunley*, and to her dedicated staff and organization.

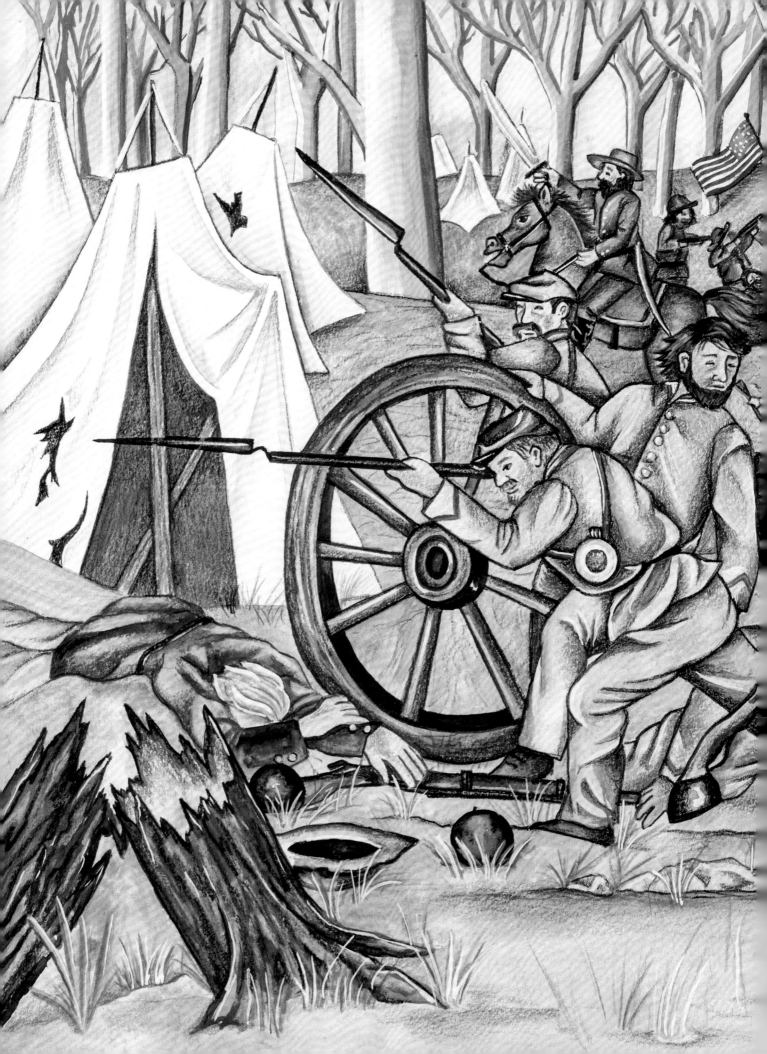

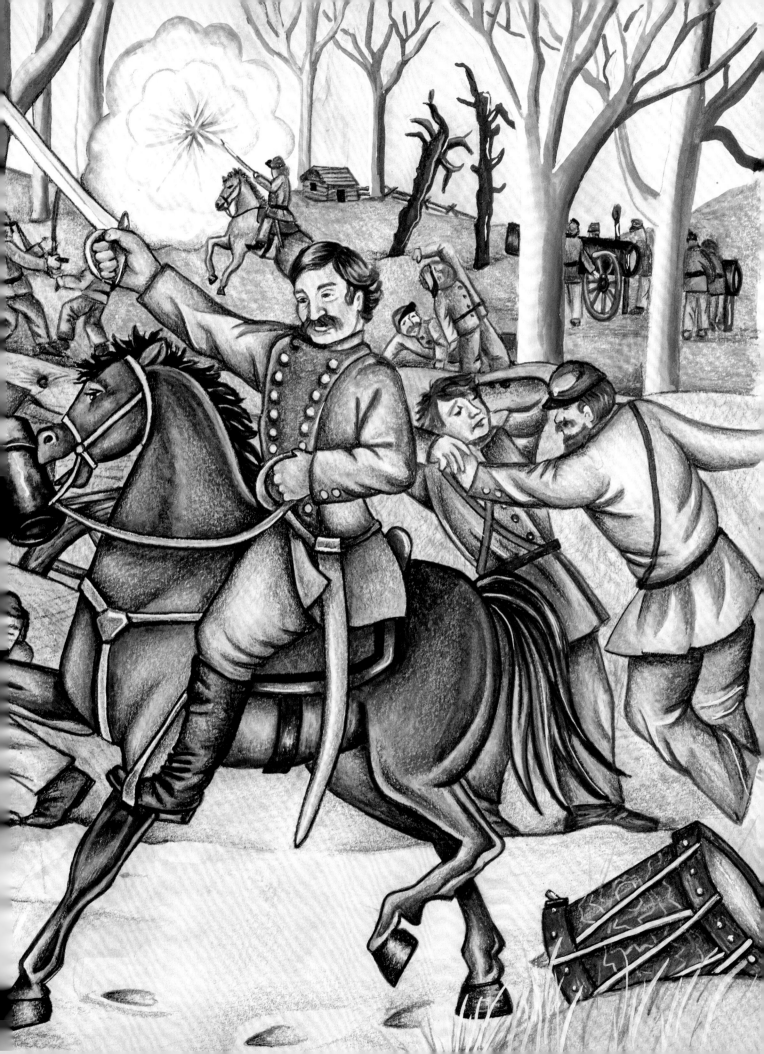

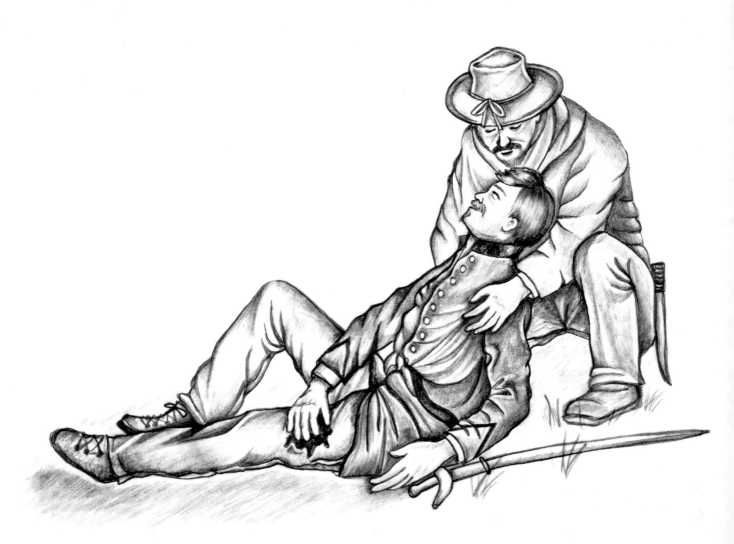

CHAPTER 1

THE BATTLE OF SHILOH

Secretly, stealthily, General Albert Sidney Johnson assembled, readied, and rallied his Confederate troops to fight. The soldiers, guns, and ammunition were only two miles from the Union army's camp near Pittsburg Landing on the Tennessee River.

The Union generals were sure there were no Confederate troops anywhere close to them. They were so confident of their safety that they did not even send out any patrol scouts to look for the enemy. Because they did not take precautions, they were not prepared for an attack.

Very early Sunday morning, on April 6, 1862, the Confederate troops launched their surprise attack against the Union troops. General Johnson was killed in the fierce fighting, but General P. G. T. Beauregard took command. Yankee general William Tecumseh Sherman had three horses shot out from under him, but he kept on fighting.

Both armies had approximately 40,000 men. The Confederates had the advantage of their surprise attack, but the Union had better weapons. After two days of fighting, the Union won this fight, which was called the Battle of Shiloh.

On that first morning of the battle, a young Confederate soldier named Lt. George Dixon placed a twenty dollar gold coin in his left pants pocket. He hoped it would bring him good luck in the coming fight.

With the shiny flat coin tucked safely out of sight, Dixon fought bravely with the 21st Alabama Regiment in the Battle of Shiloh. Early in the battle, a Yankee bullet tore into Dixon's left thigh. His wound was so serious that he dropped his rifle and fell to the ground, certain that he would die. By the end of that battle, more than 23,000 men were killed, wounded, missing, or taken prisoner. Dixon was lucky—very lucky. Amazingly, the bullet (called a Minié ball) hit and actually bent the gold coin in his left pocket. The bullet slammed into the coin with such force that it left a mark on Dixon's thigh bone. Most important, the coin stopped the bullet, saving Dixon's leg. And his life!

This life-saving coin was now precious to Dixon. He had the coin inscribed "Shiloh, April 6, 1862 My Life Preserver GED." He told his friends about the coin, and the miraculous way it saved him from being killed in battle.

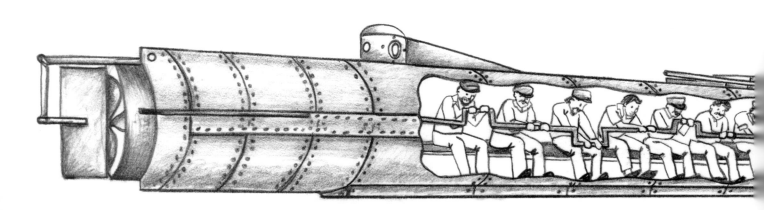

CHAPTER 2

LT. GEORGE DIXON AND THE *H. L. HUNLEY*

Although Lt. Dixon recovered from his bullet wound, he walked with a limp and was not able to return to fighting with his regiment.

Dixon discovered a way to help the Confederacy, even though he could not participate in battles. He joined a group of men led by Horace Hunley in Mobile, Alabama. They were designing and building a top secret "fish boat" that would operate underwater and destroy enemy ships without being seen. In spite of a lot of planning, hard work, and expense, the men had to sink the first "fish boat" they had built to keep it from being claimed by the Yankees. The second "fish boat" sank when it was being towed. Instead of giving up, the builders kept improving their invention. Although engines had been invented, the builders could not install an engine both small enough and powerful enough to move the sub through the water. In place of an engine, the *Hunley* was propelled by hand cranks which were operated by the crew.

In July, 1863, the third "fish boat" was ready for testing. The *Hunley* performed perfectly during a trial run in Mobile Bay. The "fish boat" submerged, hit the practice target with a torpedo, and resurfaced a safe distance from the explosion. The *Hunley* was deemed ready for battle. Charleston, struggling to survive the stranglehold of the Yankee blockade, was more than ready for the *Hunley*.

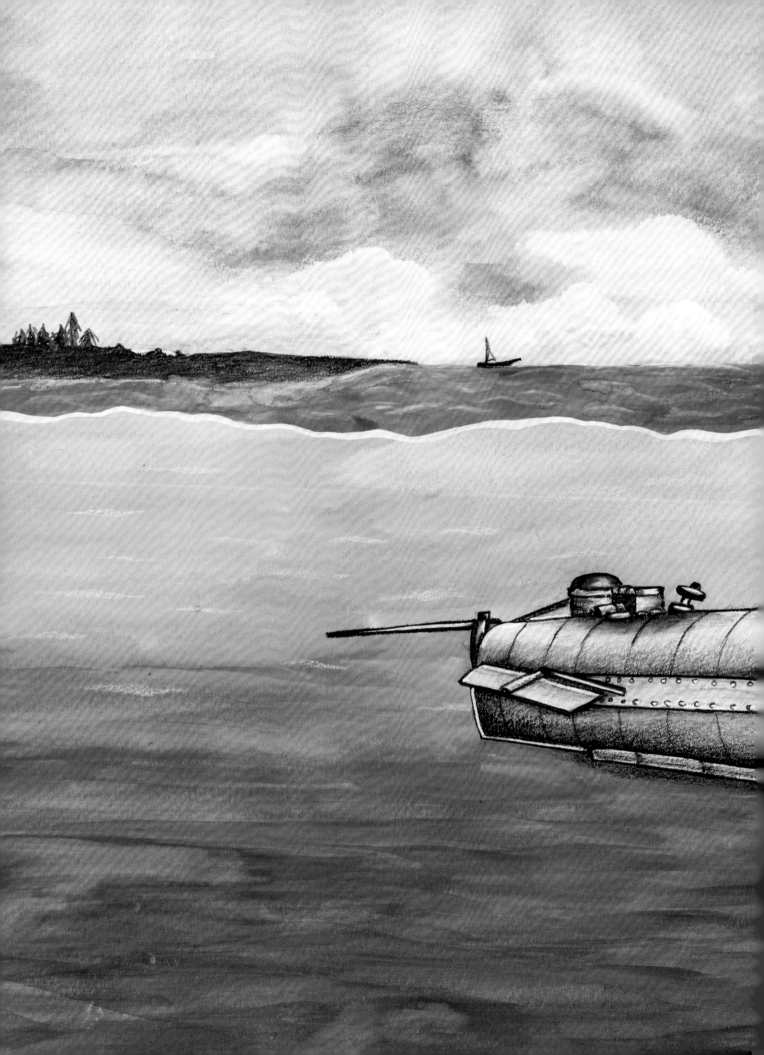

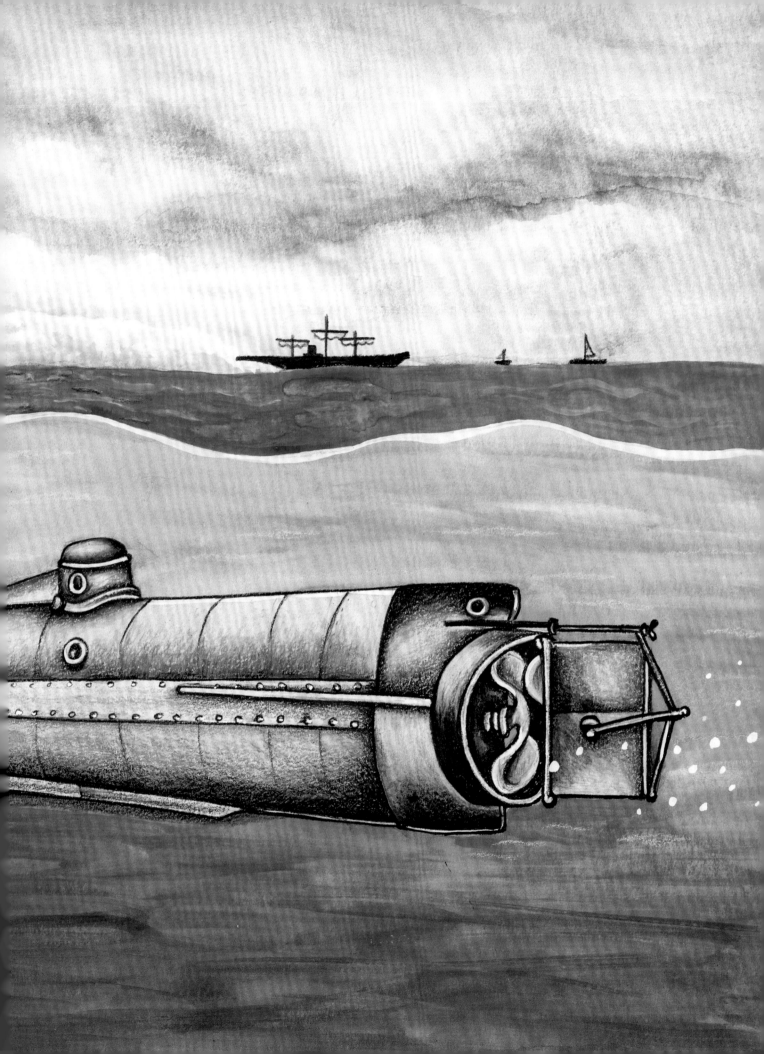

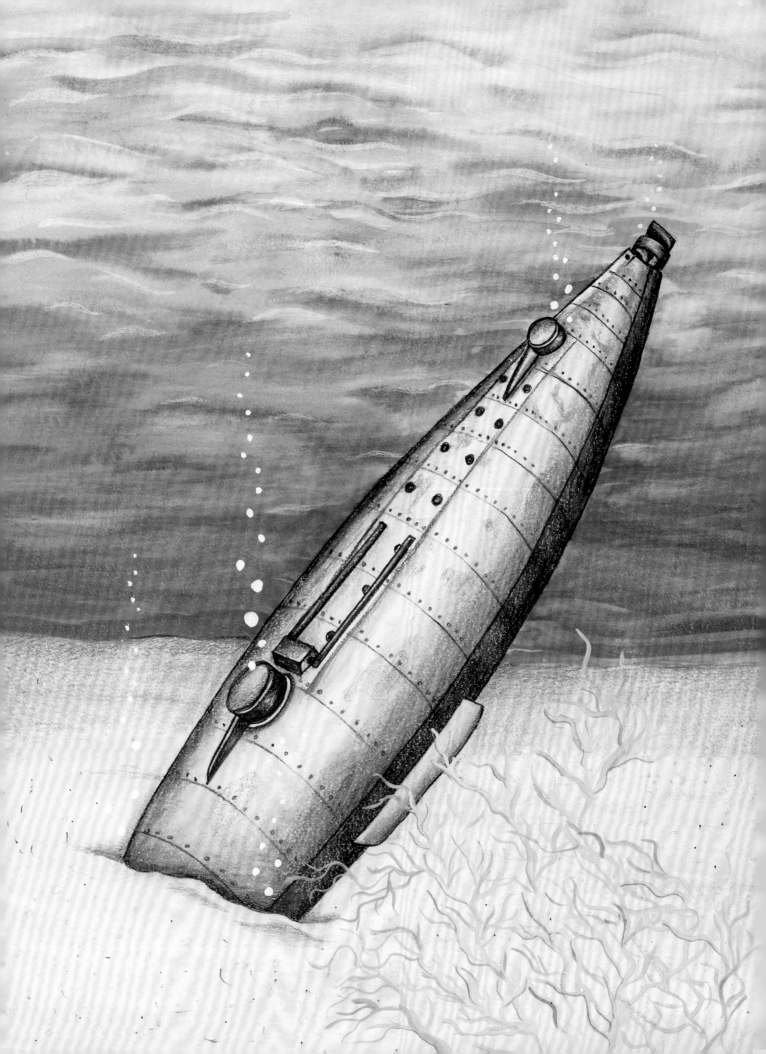

CHAPTER 3

THE BLOCKADE OF CHARLESTON

The final months of 1863 were grim for the South. Charleston, under the command of General P. G. T. Beauregard, had endured Yankee shelling for more than 100 days—even on Christmas. Confederate troops were worn out. They were outnumbered by the Yankee troops. Supplies of food and ammunition were running low because of the Yankee blockade of Charleston harbor. The unrelenting bombing had reduced the beautiful, proud city to a wrecked and ruined ghost town. All civilians who were able to leave had fled to find safety. Beauregard had only one hope for breaking the stranglehold that the South Atlantic Blockading Squadron had imposed on Charleston harbor. He sent for the "fish boat."

Because the submarine was believed to be a secret weapon, it was wrapped in camouflage before being loaded onto a train car bound for Charleston. When it arrived, even the Charleston newspaper kept the secret. Unfortunately, Yankee spies had secretly studied the *Hunley* and knew exactly how it looked and how it worked.

The Yankees used this information from the spies to protect their blockade vessels from underwater attack. They moved their ships to shallow water. They told their crews to be on the lookout for a long, dark boat that looked like a giant log.

While the Yankees were protecting their ships, the Rebels were perfecting their submarine techniques. Disaster struck as they practiced. The submarine sank, swamped by the wake of a ship that happened to be passing by. Five men drowned.

Horace Hunley himself arrived in Charleston. He convinced General Beauregard to let him try again with an experienced crew. With the general's permission, he raised the sunken sub from the harbor floor.

Hunley arranged for cleaning the sub, and took it out on some practice runs. The vessel performed well—so well that Hunley took the sub out for a "dress rehearsal." Unfortunately (very unfortunately) Hunley had forgotten to close the seacock, a valve designed to let water in or keep it out. Sea water poured in, and the submarine became so heavy with water that it could not surface. All eight crew members (including Hunley himself) died. In the wake of this latest disaster, the submarine was justifiably ridiculed as "the iron coffin," and called other equally unflattering names. General Beauregard famously labeled the submarine as "more dangerous to those who use it than the enemy."

This second sinking might well have put an end to the *Hunley*, except that Lt. Dixon still staunchly believed in its capabilities. General Beauregard, who had been Dixon's commander at the Battle of Shiloh, listened to Dixon's arguments for a chance to try the submarine one more time. Dixon was convinced that he could avoid the operator errors of the past. Beauregard probably wanted to deny Dixon's passionate request, but he was under tremendous pressure to produce a victory. Beauregard was dealing with the constant stress of battered forts, the unending bombardment of Charleston, discouraged soldiers, and Confederate President Jefferson Davis's expectations for a Confederate victory.

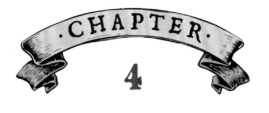

CHAPTER
4

LAST CHANCE

With General Beauregard's reluctant permission, Lt. Dixon raised the *Hunley* again. The remains of the men inside were respectfully removed and buried. The submarine was cleaned, and a new crew was assembled. Weeks of training runs took place from December, 1863, to January, 1864. The crew lived in Mount Pleasant, and practiced off of Sullivan's Island, near the inlet where they kept the *Hunley*.

Dixon and Beauregard felt the same overwhelming pressures of time and resources. The survival of both Charleston and the Confederacy depended on the success of Dixon's mission. If the *Hunley* could blow up ships and break the blockade in Charleston harbor, the Confederacy had a chance to win the war. If the *Hunley* failed, the South faced certain defeat.

The determination of the South was matched by the determination of the North. Charleston, the second largest port in the United States, had been the center of the thriving slave trade. The soldiers in this town had had the boldness to attack the Union at Fort Sumter. The total destruction of Charleston was a high priority for the North.

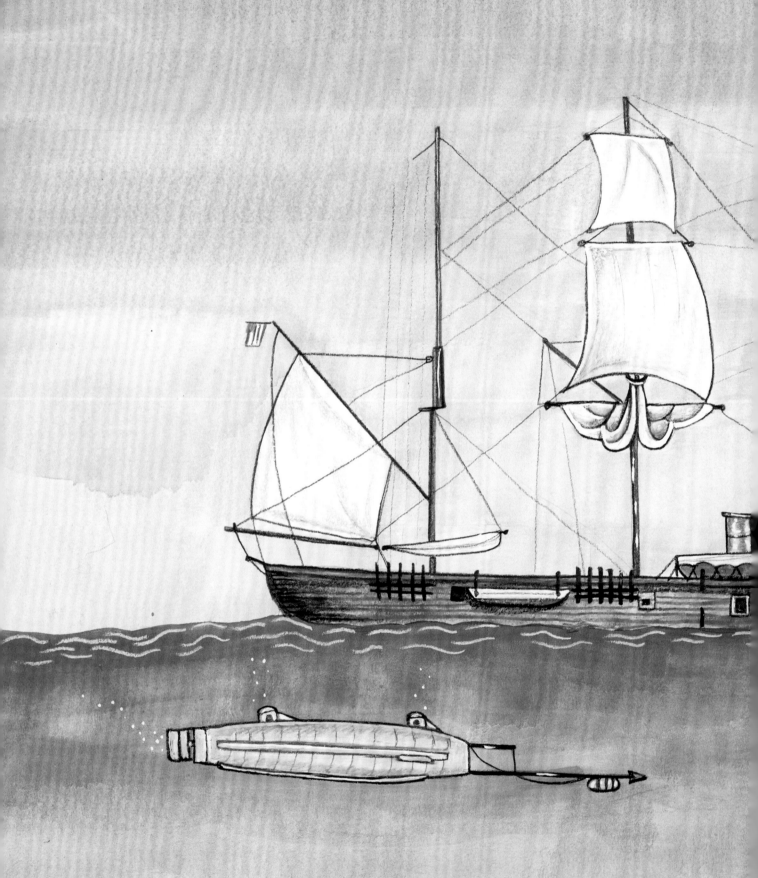

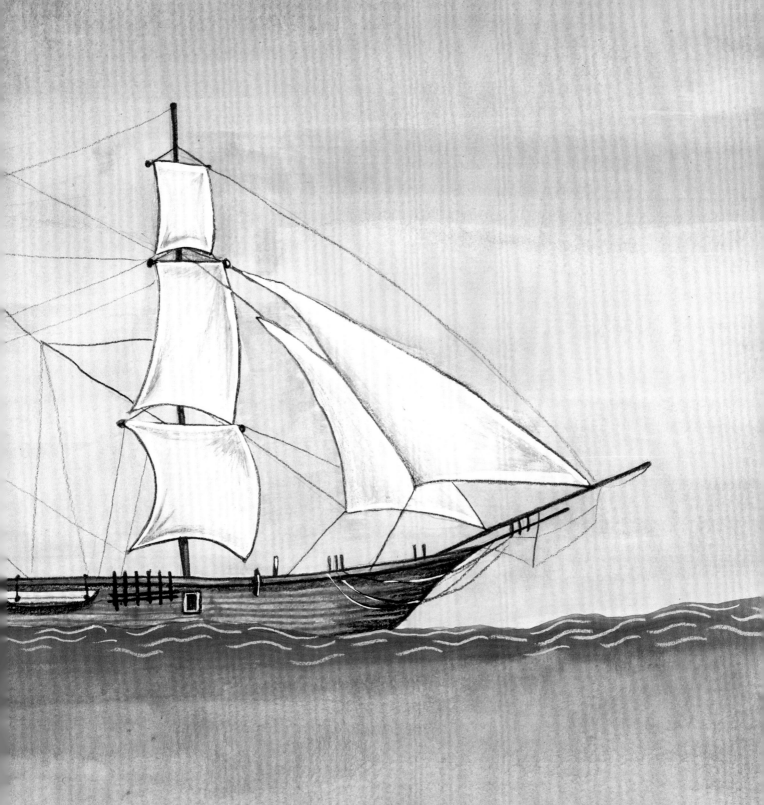

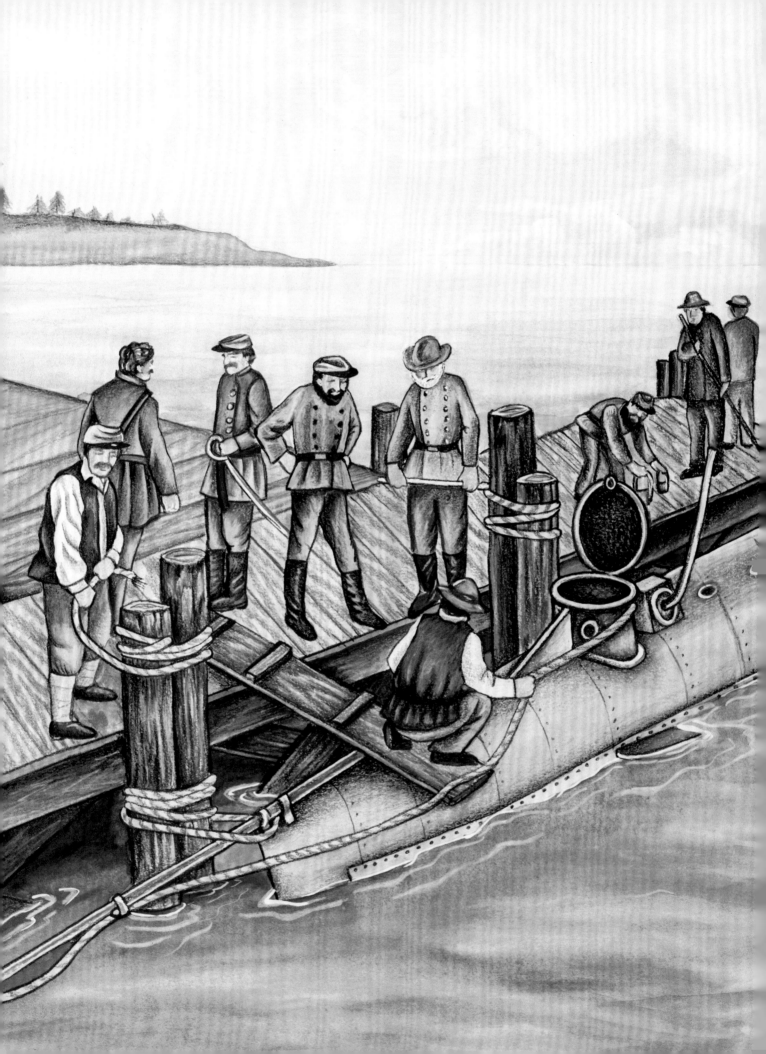

CHAPTER
5

THE *HUNLEY*
SINKS THE *HOUSATONIC*

Lt. Dixon waited impatiently for the calm seas that were necessary for the *Hunley* to operate properly. Finally, on the cold, clear, moonlit night of February 17, 1864, the weather cooperated. The men climbed down through the hatch and into the narrow, dank submarine. Dixon instructed the soldiers left behind on Sullivan's Island to light a fire to guide the *Hunley* home after the mission was complete.

Dixon had carefully overseen every aspect of the submarine's refurbishment. He had trained his crew with painstaking attention to detail. At one time, he had planned to use the spar on the front of the submarine to stick the explosives into the side of the Union ship the *Housatonic*. When the explosives were in place, the submarine would back away before the powerful explosion took place. Technical considerations caused a change of plan. Now the torpedo, filled with 135 pounds of black powder, was bolted to the *Hunley*'s spar. The *Hunley* could not back away from the explosives because they were attached, and would detonate a mere sixteen or seventeen feet from the submarine.

Dixon had no way of testing what would happen to the submarine after their explosion set off the inevitably powerful shock waves of water. He needed good luck to survive the known and the unknown. To assure that luck, he put his bent gold coin deep in his pocket. That coin had saved his life at Shiloh. He desperately hoped the coin would work its lucky, life-saving magic once again on his mission in Charleston's harbor.

For two hours, the men cranked to keep the submarine moving over the surface of the sea toward their target, the 205-foot sloop-of-war U.S.S. *Housatonic*. The *Housatonic* had been targeted specifically because it was at the far end of the line of blockade ships, the place most removed from help.

Robert Flemming, a free black man on the deck of the *Housatonic*, recognized the *Hunley* from the descriptions that spies had given to the Yankees. Flemming was certain he was not seeing a log, because this object was moving against the current instead of with the current. Flemming was insistent, but the other guards didn't heed his warning until the *Hunley* was too close for the ship to fire its cannons. Belatedly, the crew fired their rifles, but the bullets bounced off of the metal sub.

As the crew of the *Housatonic* scrambled to protect themselves and their ship, Dixon maneuvered the *Hunley* around the bow, and planted the torpedo under the bilge line on the side of the ship. The torpedo detonated! The explosion was so powerful, and the hole blasted in the *Housatonic* was so large, that the ship sank within five minutes. This historic accomplishment made the *Hunley* the first submarine ever to sink a ship in battle.

Back on Sullivan's Island, the soldiers thought they saw a signal light they believed to be from Lt. Dixon. As instructed, they lit the fire that would guide the *Hunley* back home. They waited expectantly. They kept the fire burning all night. The *Hunley* never returned.

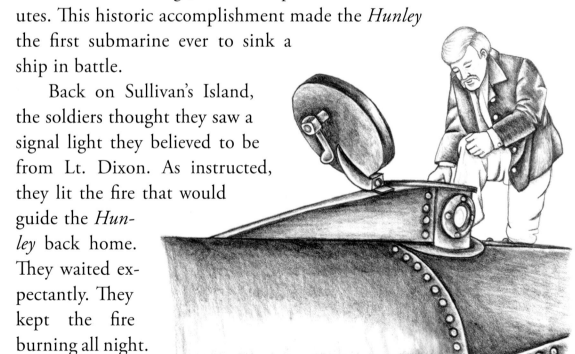

CHAPTER
6

THE END OF THE CIVIL WAR

The loss of the *Hunley* was one more lost hope amid the overwhelming losses of the Confederacy. After 585 days of siege, the ruined city of Charleston surrendered. On April 9, 1865, the Confederate general Robert E. Lee surrendered to the Union general Ulysses S. Grant at Appomattox Courthouse, Virginia.

The Confederate surrender marked the end of the Civil War and the victory of the Union.

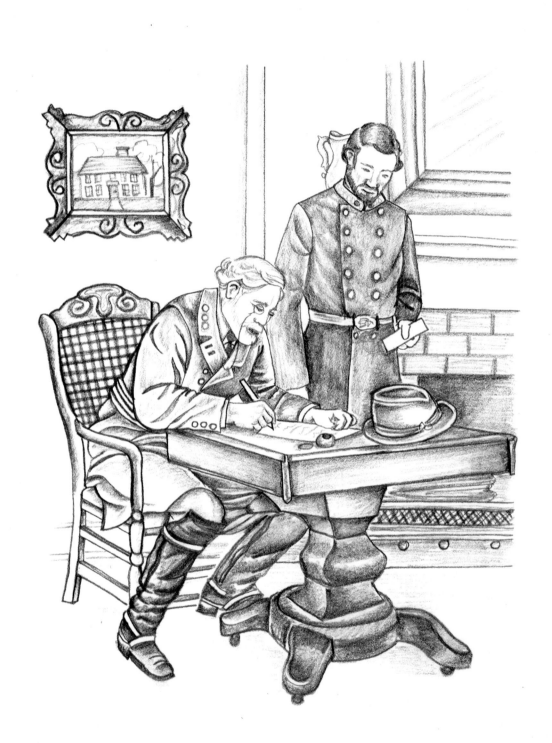

CHAPTER 7

THE LONG SEARCH FOR THE *HUNLEY*

The fate and the location of the *Hunley* remained a mystery for more than 130 years. A circus owner offered a $100,000 reward to anyone who would find the submarine for him to feature in his museum. Numerous *Hunley* hunters claimed to have found the submarine. Every claim turned out to be a hoax.

The *Hunley,* buried under a blanket of sand, needed a hero to find her. Clive Cussler—an author, an authority on ship wrecks, and a man keenly interested in both underwater archeology and the Civil War—was the perfect person for this mission. His statement, "Shipwrecks are never where they're supposed to be," proved to be accurate in the case of the *Hunley.*

Cussler's team of divers searched on and off for fifteen years, overcoming numerous problems and challenges. One big nuisance was the miserable stinging jellyfish. A solution was found when a resourceful diver pulled panty hose over his head to prevent getting stung.

Even though a dive team had explored one particular site during a previous expedition, they had an educated hunch that they should reexamine that same place on May 3, 1995. It was four miles from shore with a water depth of twenty-seven feet.

As a diver searched the sea bottom, he discovered a large metal tube which he surmised might be a boiler from the *Housatonic.* On closer inspection, he felt a hinge. A hinge! Submarine hatches have hinges. He had

found the *Hunley*! There was only one thing appropriate for him to do. He hugged it.

Clive Cussler and his team announced their exciting discovery to the people of Charleston and the world. They made a deal: They would disclose the secret location of the submarine only after millions of dollars were raised to bring the *Hunley* safely from the ocean floor, and house it in a facility where archaeologists and conservators could study and preserve it.

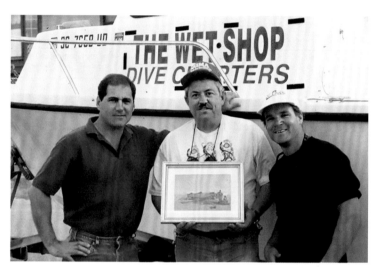

Wes Hall, Ralph Wilbanks and Harry Pecorelli, underwater archaeologists working for Clive Cussler, found the *Hunley* on May 3, 1995. In this photograph that marks the day of the discovery, Wilbanks holds a copy of a famous picture of the *Hunley* painted by C. W. Chapman.

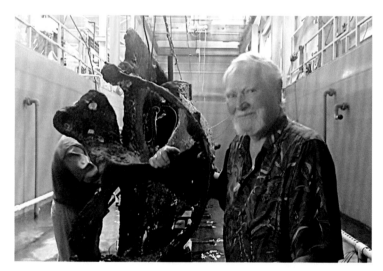

Clive Cussler, a famous novelist and leader of NUMA (National Underwater and Marine Agency), visits the *Hunley*. He had read about the *Hunley* in a history book and was inspired to find the lost sub. NUMA has found many wrecks and preserved much U.S. maritime history.

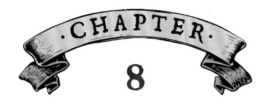

RAISING AND RESTORATION OF THE *HUNLEY*

The Friends of the *Hunley,* an organization dedicated to preserving the *Hunley,* raised money for this cause for five years. On August 8, 2000, specially engineered equipment raised the *Hunley,* while 20,000 wildly enthusiastic people looked on and cheered. It was a day of joyful celebration and reverent remembrance. As one man emotionally observed, "She's coming home. A little bit late, but she's coming home." The *Hunley,* crusted over with coral and oyster shells and filled with thirty tons of sand, was a beautiful and welcome sight. From the ocean floor, the submarine was taken to a cold water storage tank, constructed especially to preserve the vessel.

One mystery (the mystery of the *Hunley* location) was solved. Four mysteries remained.

The second mystery: How and why did the submarine sink? The latest research reveals that the sub was a mere sixteen or seventeen feet from the explosion of 135 pounds of gunpowder. Was the sub swamped by waves of sea water caused by the explosion?

Archaeologists have discovered a break in the *Hunley*'s hull. They have found a broken view hatch. The *Hunley* was built with a casing to protect the propeller. Now half of that propeller shroud is missing. What caused these parts to break or disappear? Did any of these broken parts cause or contribute to the sinking?

More research will reveal more clues and more theories will be developed. For now, how the *Hunley* sank is still the major mystery.

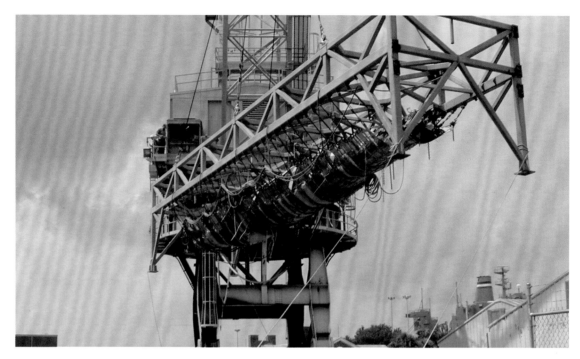

Raising the *Hunley* was an ingenious process. A huge metal cage (called a "truss") was lowered over the sub and stabilized on pilings driven into the sea floor. The sub was tied to the truss with 32 wide straps that were attached by divers. The *Hunley* was held in place and cushioned by a special foam.

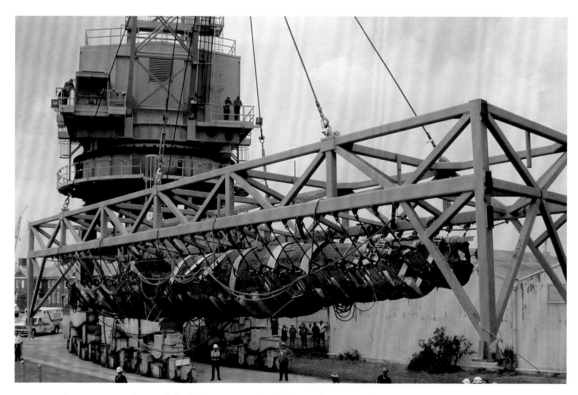

A crane on a barge lifted the encased sub from the ocean floor and set it down on the recovery barge. Divers who attached the lift straps found many pieces of the *Hunley* that had broken or rusted off. Nearly every piece of the sub was recovered.

Archaeologists, conservators, and volunteers began the painstaking work of sifting through the contents of the submarine. The remains of all eight crew members were carefully and respectfully removed for later burial. The scientists found artifacts including pipes, bottles, a leather boot, and 160 buttons. They also found a crank handle, a compass, a lantern, a pocket knife, fabric, and even hair.

The excavation was nearing completion. Maria Jacobsen, the chief archaeologist who had worked on shipwrecks all over the world, slid her hand through the sea muck that had built up at Lt. George Dixon's place on the crew bench. When her tightly clenched fist emerged, she asked that water be poured over her hand to wash away the sludge.

There, glinting as brightly as it had 135 years before, was Dixon's bent gold coin. The coin had been mentioned in historical accounts of the time. It was clear that the coin had existed, but until Jacobson's discovery, the location of the coin was unknown.

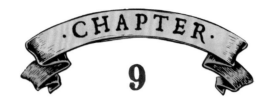

9

LT. DIXON'S GOLD COIN

The third *Hunley* mystery is where and how Lt. Dixon got the coin. Historical records have not answered that question, at least not yet. Perhaps the coin just randomly happened to be in Lt. Dixon's pocket at the Battle of Shiloh.

Or perhaps, just perhaps, there's another possibility.

Historical records support the existence of Queenie Bennet, a young woman who lived during the Civil War. We know she loved the South, and we know she was feisty because of this true story:

During the war, Yankee soldiers marched into Queenie's hometown of Mobile, Alabama. They tore down her beloved Confederate flag and hoisted the Union flag in its place. Queenie was foot-stomping furious.

In outright defiance of the Yankees, Queenie and her friends enthusiastically slashed the rope, bringing down the detested Union flag in an undignified heap. Although this was exceptionally unladylike behavior for young women in the 1860s, these girls were proud of themselves. They

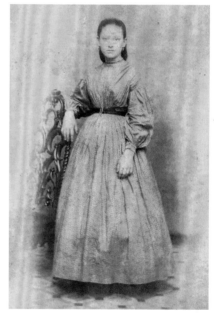

Queen Bennett was a southern belle from Mobile, Alabama. Many people believe the legend that she gave Lt. Dixon the gold coin that saved his life in the Battle of Shiloh. This coin was found during the excavation of the *Hunley*. Although there is no proof of a connection between Bennett and Dixon, the story is charming, and the coin is real.

remained proud when the Yankees arrested them! From that day on, Queenie's family called her "The Little Rebel."

For generations, an oft-told tale linked Queenie Bennet to Lt. George Dixon. According to this romantic story, Queenie and George fell in love. Before George left to fight in the Battle of Shiloh, Queenie gave him a $20 gold coin. Queenie meant for this keepsake to remind George of her love and bring him good luck. As we know, the coin, tucked in his left pants pocket, saved his life when it was hit by a bullet.

This romantic story is fun to hear and tell, but it is not supported by historical proof. Even Queenie's descendants had never heard of the coin until a researcher told the family about a newspaper article mentioning a letter that referred to Queenie and Lt. Dixon. To this day, no one has found that article or any letters to authenticate the story. Although Queenie's relatives and many other people may believe this story, no picture or mention of Lt. Dixon has been found in Queenie's belongings.

Just as there were two sides in the Civil War and both sides believed in their cause, there are two sides in the debate over the truth of this legend. Both sides are certain they are right.

In addition to the unsolved mystery of where Lt. Dixon got his gold coin, there is a fourth unsolved mystery: Who was George E. Dixon? We do know that he was a steamboat engineer. From records of the time, we know that he stayed at a boarding house run by Queenie's family. We know he was wearing expensive clothing and carried a watch, a broach, and a ring on the mission. These artifacts were found with his bones. We don't know where he was from, how he became wealthy, or even what name is represented by his middle initial "E." As yet, we have no photograph of Dixon.

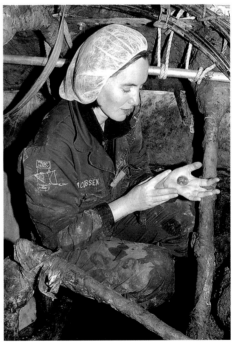

Maria Jacobson was senior archaeologist on the *Hunley* project. She found Lt. Dixon's legendary gold coin on May 23, 1995, as she prepared to remove his remains from the sub. This was one of the most exciting and important discoveries of the excavation.

· CHAPTER · 10

THE FUTURE OF THE *H. L. HUNLEY*

The fifth intriguing *Hunley* mystery: What other clues exist, and are out there waiting to be discovered? Just recently, someone found a notebook kept by Horace Hunley. The Shelby Ironworks, that helped to construct the submarine, has kept 400 boxes of records dating back to work they did before the Civil War. Those records have not been searched—yet. As Americans gain a greater appreciation for their history and genealogy, more history will be preserved.

Since the raising of the *Hunley* in the year 2000, it has been protected by immersing it in a cold water tank with a mild electric current. In May, 2014, scientists began the process of removing the sand and shell that had

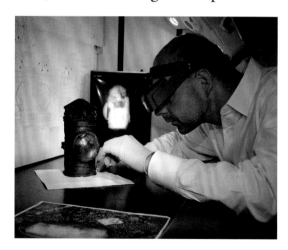

Paul Mardikian, senior conservator, is shown working on a lantern found in the *Hunley*. He had earlier experience working on artifacts from the Civil War, and he had also worked on artifacts from the Titanic.

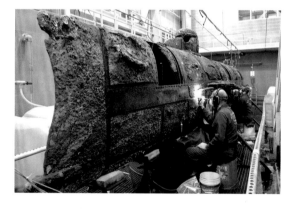

Paul Mardikian is working to remove the concretion from the *Hunley*. During his work as a conservator, he discovered that the *Hunley*'s torpedo was actually bolted to the spar. This meant that the sub could not back out of the way of the explosives it planted. This important finding changed our understanding of the sub's history.

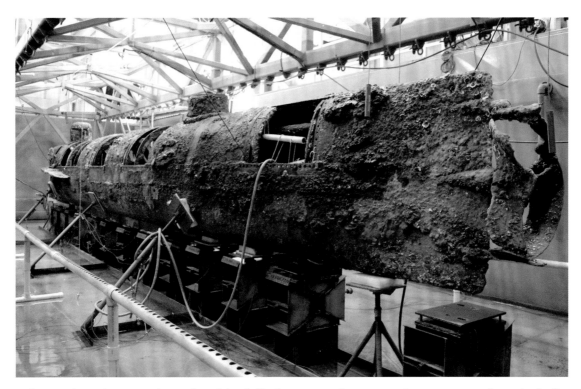

The *Hunley* is shown in the midst of the difficult process of removing the concretions from the hull.

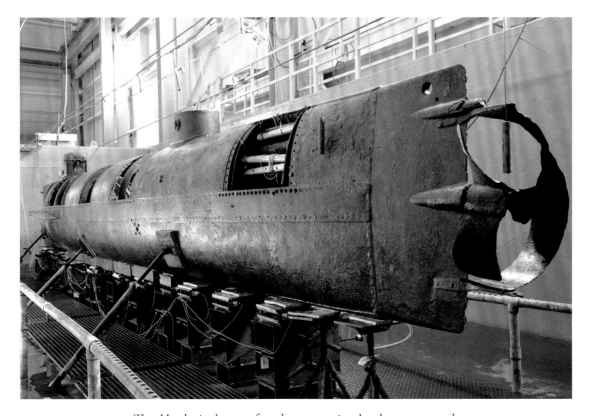

The *Hunley* is shown after the concretion has been removed.

hardened on the *Hunley's* hull during its 136 years underwater. First, scientists placed the *Hunley* in a chemical bath that loosened the concretions. Conservators then carefully scraped the sediment off of the hull.

This procedure to remove the concretion has always been part of the plan to conserve the *Hunley*. Scientists believe it is the only way to save the sub from disintegration. Soaking, scraping, and conserving may not sound very exciting. However, this is the process that gave us our first look at the actual hull. Examining the hull will help us learn more about how the *Hunley* was designed and operated. It is even possible that the exposed hull will reveal why the *Hunley* sank.

This process of conservation and stabilization is expected to last from five to seven years. By then, there's a plan to build a new home for the *Hunley*. This will be a museum on the former Navy Base in North Charleston, South Carolina.

History rhymes with mystery. Maybe that's not by chance.

Could you be the researcher who builds on current and future discoveries to solve the *Hunley* mysteries? Of course you could. You just started!

BEHIND THE SCENES AT THE
WARREN LASCH CONSERVATION CENTER
Home of the *H. L. Hunley*

. .

CONSERVATOR

Joanna Rivera-Diaz, *Hunley* Conservator: "Artifacts tell a story."

The process for a conservator is

1. Obtain an artifact. (It may look like an ordinary rock.)
2. Figure out what the artifact is.
3. Draft a treatment plan.
4. Test.
5. Clean the artifact and stabilize it to prevent further dissolution.
6. Package the cleaned artifact to eliminate oxygen and humidity.

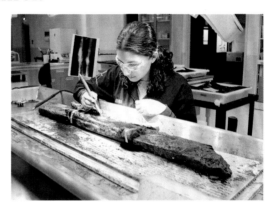

Joanna Rivera, conservator, is working in the lab on the *Hunley's* depth gauge.

Conservators do have favorite artifacts, but they aren't necessarily the artifacts you would guess. Lt. Dixon's gold coin is justifiably famous, but other items are equally fascinating.

Wood is difficult to conserve, because the accumulated water must be removed. Conservators have actually restored matches, with their burnt ends intact. They've restored pencils, both the wood and the graphite. One of the pencils is barely an inch long.

Other amazing "saves": an oil can with oil still in it; a pipe with tobacco still inside, buttons and a wallet from one crewmember, and a pen knife from another.

Conservators train and take courses for many years before they are qualified to work on actual artifacts. Their work is important for both historical and scientific reasons.

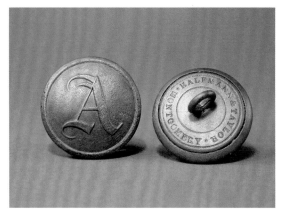

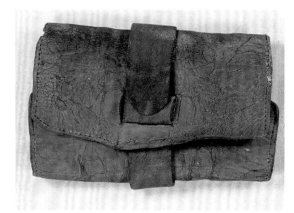

These German artillery uniform buttons were among many buttons found on the *Hunley.* The buttons are associated with crewmember C. F. Carlsen.

This wallet was found in the crew compartment. It is associated with crewmember C. F. Carlsen.

Historical: Conservators can figure out, and often prove, what happened in the past by studying facts revealed by artifacts. Anything can tell a story, even hair. George Dixon was wearing a cashmere jacket and suspenders with silver buckles. These artifacts from the past tell people in the present that he was wealthy.

Scientific: Conservators discover methods of conservation that can be used in other projects. Conservators read, use, and publish their work in international journals.

ARCHAEOLOGIST

Michael Scafuri, *Hunley* archaeologist: "Archaeology is like solving mysteries similar to the criminal cases on TV."

Archaeologists start by assembling as much evidence as they can find. They gather clues to help figure out what the evidence means. Solving archaeological mysteries is complicated because clues often disagree with each other. More information coming in may mean more complications.

Why did the *Hunley* sink? Archaeologists are hard at work on this fundamental mystery. They have assembled evidence and gathered clues. Now researchers know that the torpedo filled with 135 pounds of gunpowder was bolted to the spar. Before the *Hunley* was raised and researched, it was believed that Dixon and his crew stuck the torpedo into the side of the *Housotonic* and then backed away to a safe distance. Now we know the submarine was only sixteen or seventeen feet away from the explosion. Did the force of the explosion sink the submarine?

The view hatch on the submarine is broken. Perhaps it was shattered by a bullet from the crew of the *Housatonic.* Perhaps it was broken during the time the submarine rested on the ocean floor. Did the broken viewing port contribute to the sinking? Did it cause the sinking?

Archaeologists have found a break in the hull of the *Hunley*, and a piece missing from the propeller protection. More evidence and more clues may produce more chances for solving the mystery. What do you think happened? What you think is your hypothesis. Gather facts to support your hypothesis and create a theory. Then your theory will be one of dozens of theories attempting to explain why and how the *Hunley* sank.

Missing: Proof that anyone's theory is correct.

Hunley archaeologists have their own theories. Of course, they would like for one of their theories to be right. But most important to them and to us is to find the truth.

We may never discover the proof that finally solves this mystery. Or YOU may make that discovery if you pursue research in this field!

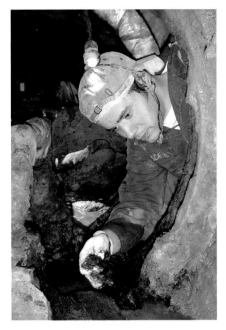

Archaeologist Michael Scufuri excavates the inside of the *Hunley* in 2001.

THE SCIENTIFIC METHOD

For centuries, curious people have used and developed the scientific method. This method is still used today to ask questions and find answers by:

1. Thinking logically
2. Considering all possibilities
3. Reaching the best possible conclusion

The scientific method may consist of three, four, or five steps. For instance, an archaeologist working on the Hunley might:

1. Make an observation (There is damage to the propeller casing)
2. Ask a question (Did the Hunley sink because of the broken casing?)
3. Form a hypothesis (The Hunley sank, or did not sink, because of the broken casing)
4. Do research/Conduct experiments
5. Accept or reject the hypothesis

At the time this book is being written, there are many theories and hypotheses about why the Hunley sank. None have been proven to be true.

Pocket knife HL-1576

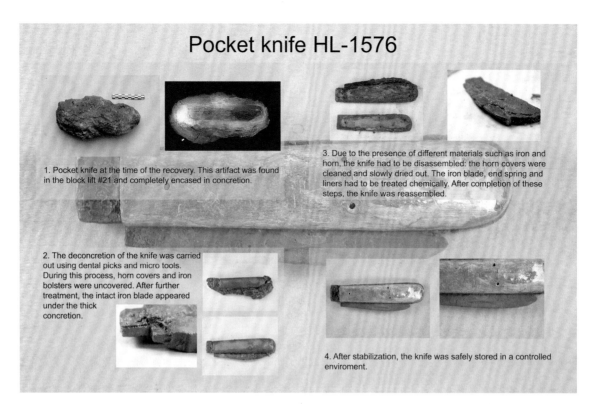

1. Pocket knife at the time of the recovery. This artifact was found in the block lift #21 and completely encased in concretion.

2. The deconcretion of the knife was carried out using dental picks and micro tools. During this process, horn covers and iron bolsters were uncovered. After further treatment, the intact iron blade appeared under the thick concretion.

3. Due to the presence of different materials such as iron and horn, the knife had to be disassembled: the horn covers were cleaned and slowly dried out. The iron blade, end spring and liners had to be treated chemically. After completion of these steps, the knife was reassembled.

4. After stabilization, the knife was safely stored in a controlled enviroment.

Pocket knife conservation storyboard

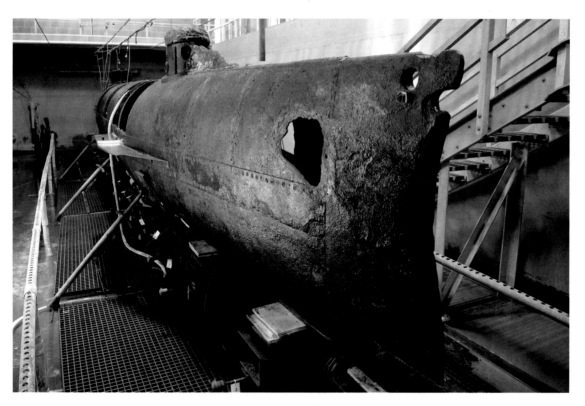

The *Hunley*, free of concretion, as it looks today in the Warren Lasch Conservation Center in Charleston, South Carolina. Visitors are welcome!

SUGGESTIONS FOR FURTHER EXPLORATION

· ·

BOOKS

Herbert, Janis. *The Civil War for Kids: A History with 21 Activities.* Chicago: Chicago Review Press, 1999.

Hicks, Brian. *Sea of Darkness: Unraveling the Mysteries of the H. L. Hunley.* Spry Publishing, 2015

Hicks, Brian, and Schuyler Kropf. *Raising the Hunley.* New York: Ballentine, 2002.

Lefkowitz, Arthur S. *Bushnell's Submarine: The Best Kept Secret of the American Revolution.* New York: Scholastic, 2006.

Osborne, Mary Pope. *Civil War on Sunday.* New York: Random House, 2000.

Polacco, Patricia. *Pink and Say.* New York: Philomel, 1994.

Walker, Sally M. *Secrets of a Civil War Submarine: Solving the Mysteries of the* H. L. Hunley. Minneapolis, MN: Carolrhoda Books, 2005.

WEBSITE

Friends of the Hunley, www.friendsofthehunley.com.

DVDS

National Geographic. *Raising the Hunley: The Resurrection of the Civil War Submarine.* 2002.

National Geographic. *Secret Weapon of the Confederacy.* 2012.